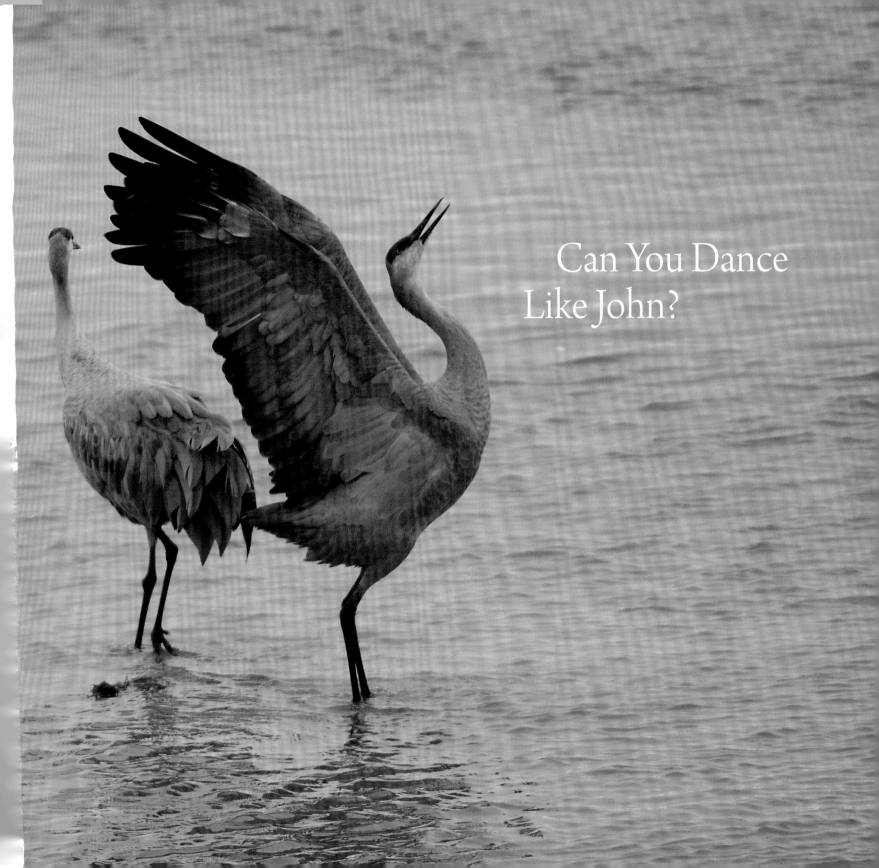

Can You Dance
Like John?

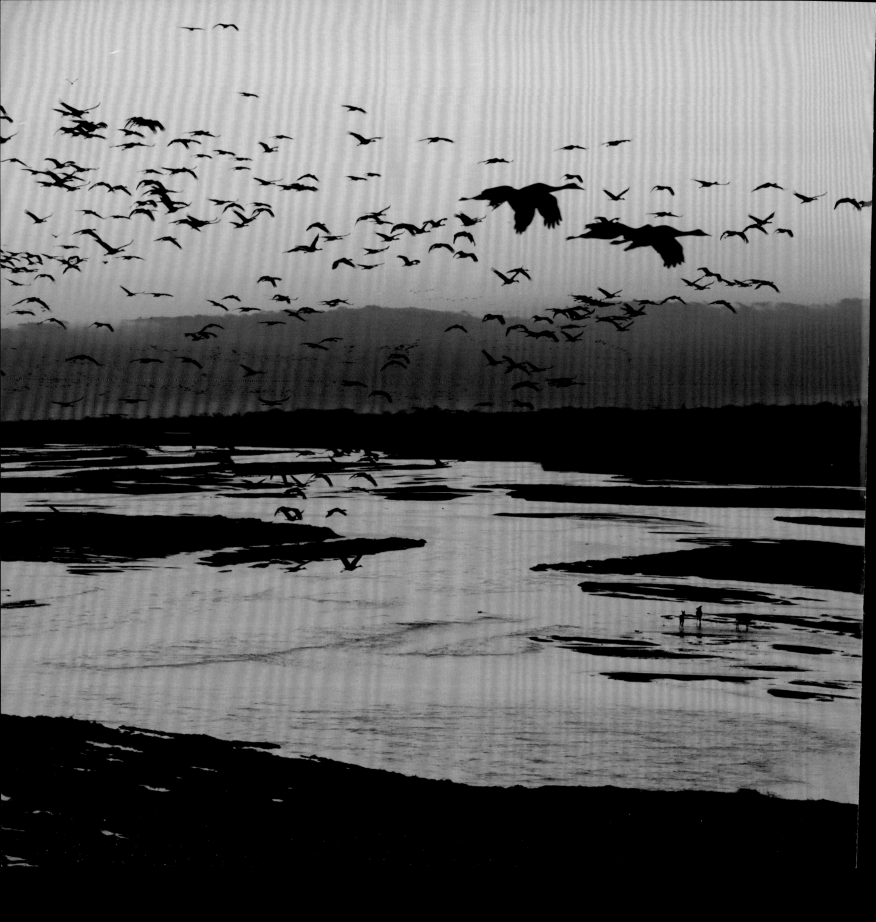

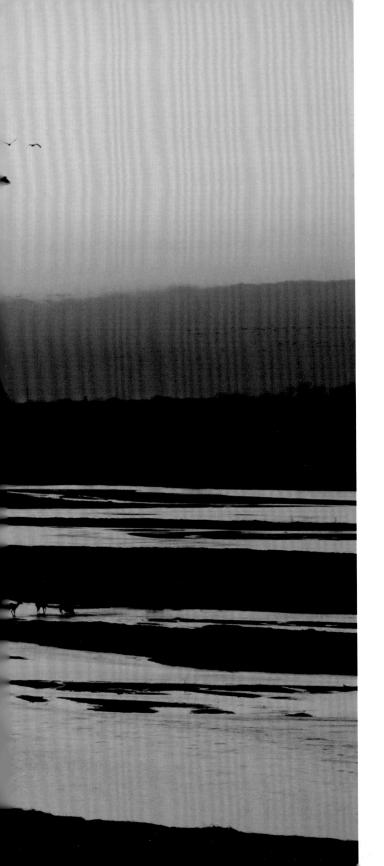

Can You Dance Like John?

Story by Jeff Kurrus

Photographs by Michael Forsberg

University of Nebraska Press | Lincoln and London

Manufactured in China ∞

Library of Congress Control Number:
2017959853

Set in Arno Pro.

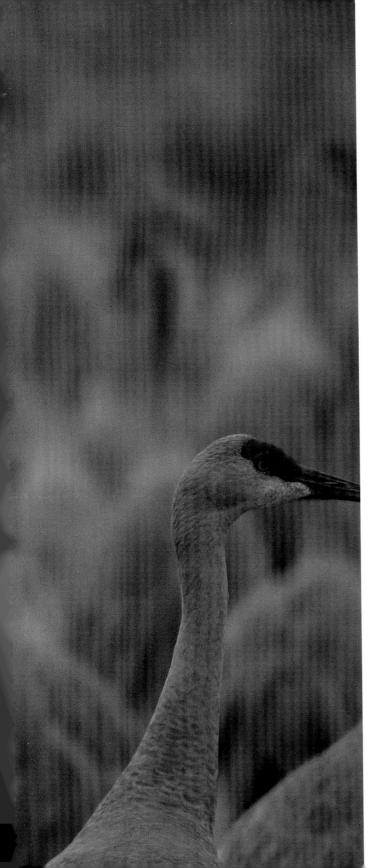

Author's Note

The idea for this book came during a signing event for the first book in this series—*Have You Seen Mary?*—which was held in the spring of 2012 at the Iain Nicolson Audubon Center at Rowe Sanctuary near Gibbon, Nebraska. Throughout the entire process of this book I have been concerned with John's fate. Sandhill cranes can meet their demise in any number of ways, including from disease, hunters, power lines, wind turbines, and even lead poisoning. More than five hundred thousand sandhill cranes endure a very long and hard migration through the Central Flyway each year—with Nebraska's Platte River Valley serving as a stopover point and the world's largest gathering of cranes.

However, there are many, like the John character in this story, that will never make it to Nebraska. I hope nature lovers of all ages will use the mystery of his passing as a learning opportunity to understand the long list of perils that can affect sandhill cranes along their migration path and also to understand how our decisions can affect what happens to animal species like sandhill cranes now and in the future.

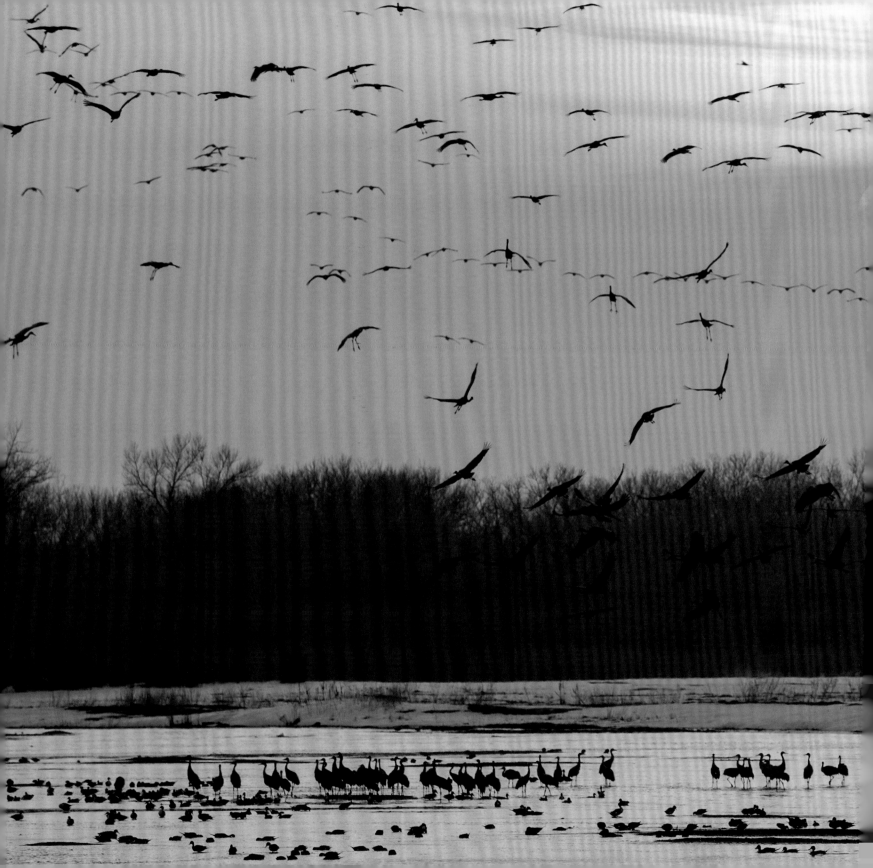

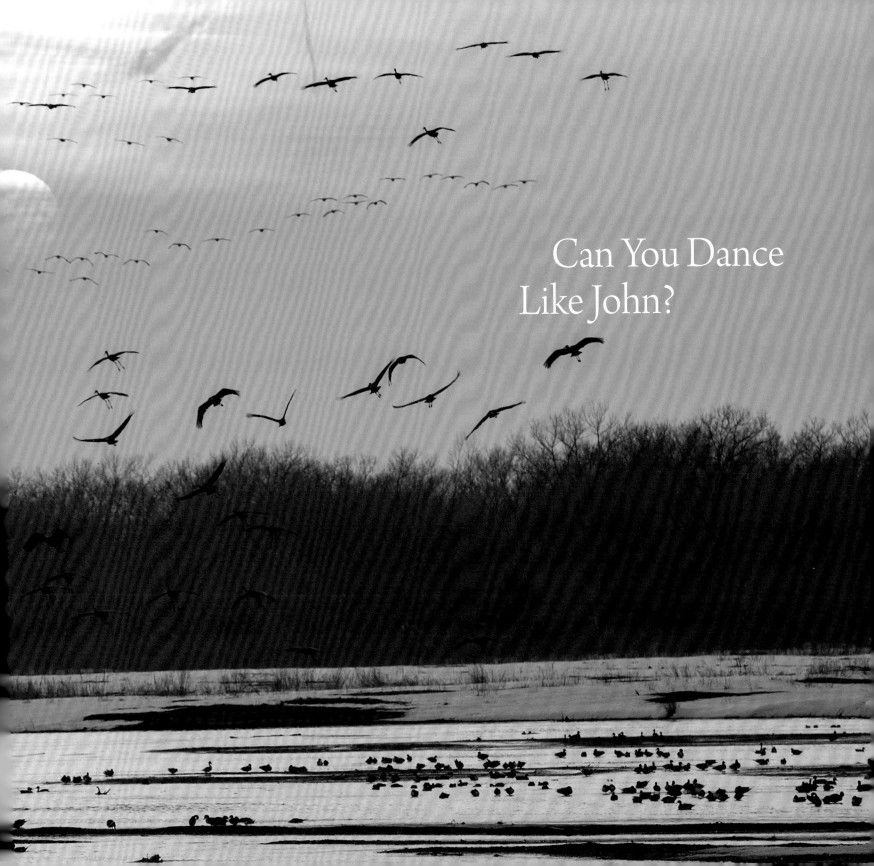

Can You Dance
Like John?

Mary and John Crane's flight back toward their nesting grounds in Alaska was starting different than most years. They had not lost each other again, like they had the year before in Nebraska, but this winter John wasn't his normal self.

They stopped more than usual through New Mexico and Oklahoma because John was considerably more tired, and more thirsty, than in years past.

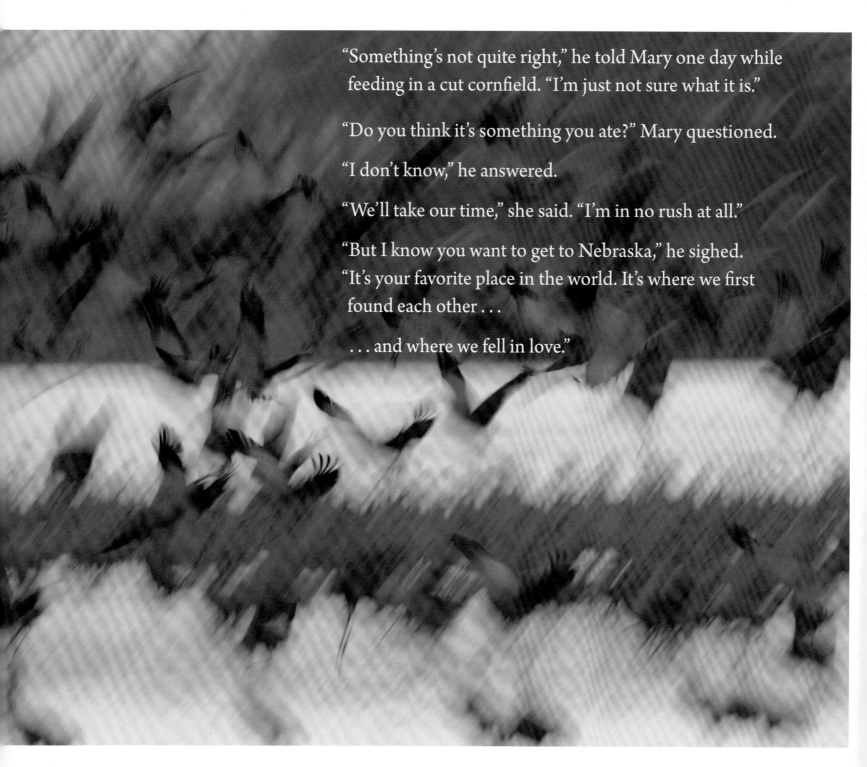

"Something's not quite right," he told Mary one day while feeding in a cut cornfield. "I'm just not sure what it is."

"Do you think it's something you ate?" Mary questioned.

"I don't know," he answered.

"We'll take our time," she said. "I'm in no rush at all."

"But I know you want to get to Nebraska," he sighed. "It's your favorite place in the world. It's where we first found each other . . .

. . . and where we fell in love."

"No," Mary interrupted sweetly. "My favorite place is wherever you are."

They fed a bit longer that afternoon with a small flock of other cranes, watching the sun begin its slumber over the Oklahoma skies.

"Maybe if I get good sleep tonight I'll feel better tomorrow," John reasoned, trying to sound upbeat. But his words came out heavy and exhausted.

"Whatever we need to do is okay," Mary responded, watching John tuck his head beneath his wing for the last time that day.

While Mary helped their small flock guard against predators for the first half of the night, John slept. Then, when the moon rose to its highest point in the sky, Mary rested.

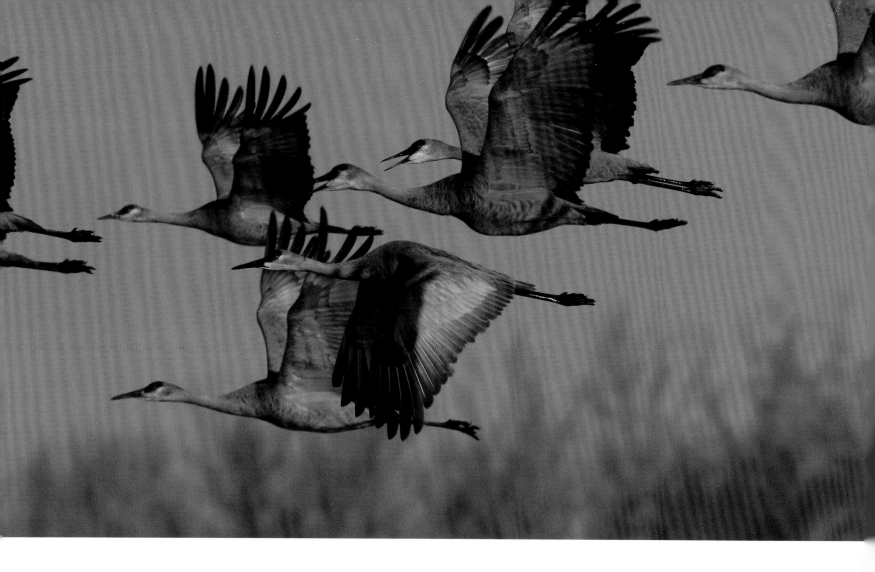

The sounds of other cranes filling the sky woke her.

Even though Mary had seen it countless times, she couldn't take her eyes away from watching them flying at sunrise.

But that sunrise went away instantly when she turned and saw John lying on the ground beside her.

"John," she whispered.

He didn't move.

"John," she repeated, this time louder.

There was still no movement.

She took her beak and nudged his body,
but it was hard and motionless.

Mary immediately began to weep.

She cried so hard and so long that she
nearly failed to see the approaching coyote.

When she did notice it, she instinctively
flushed into the air, flying higher
and higher, away from her John.

Minutes later, she floated back down
to a nearby field empty of cranes,
her body trembling. She could barely
process what had happened.

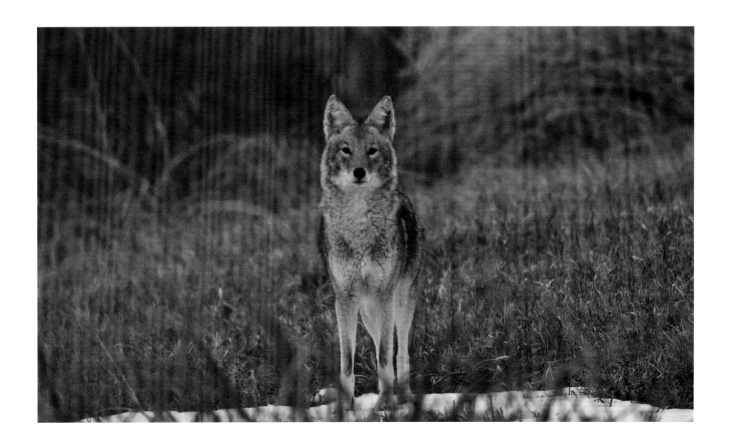

Memories of John erupted in her mind.

She remembered the first time he defended
their nest from an approaching predator . . .

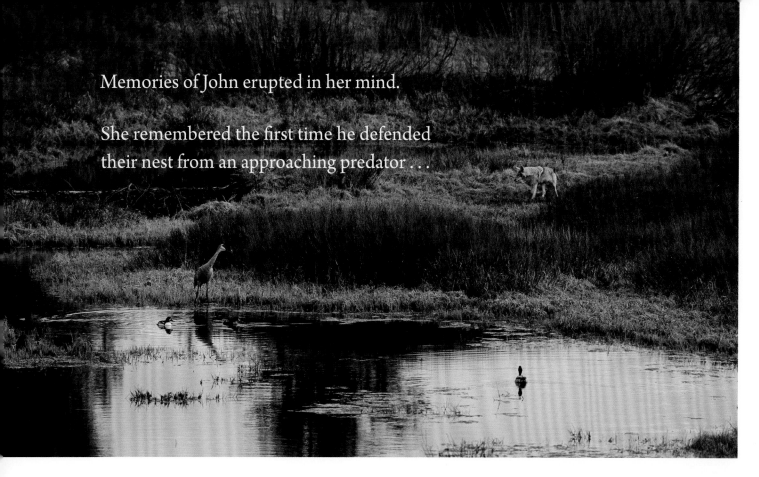

. . . when their first chick hatched . . .

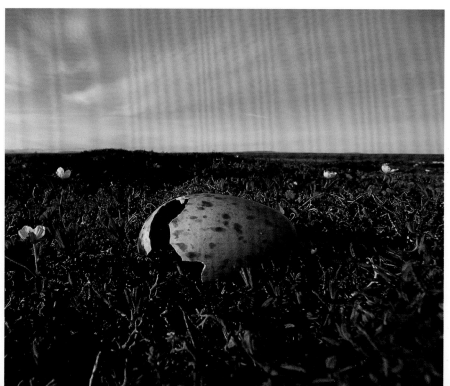

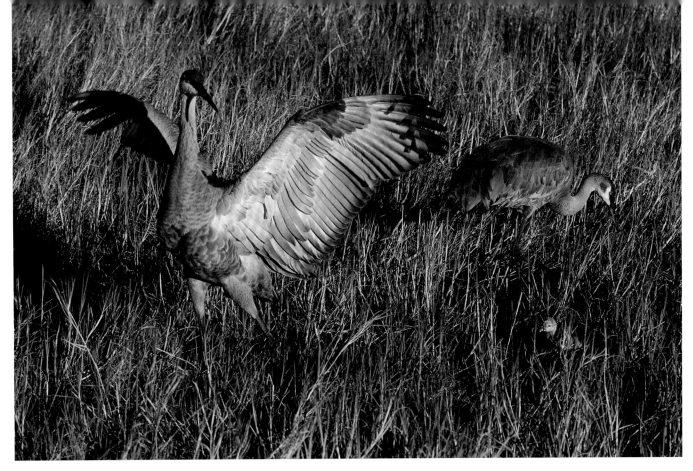

. . . and how good a father he had always been.

Mary wandered aimlessly through the field for the rest of the day, too shaken up to eat or fly. Finally, knowing she wasn't safe alone in this foreign place, she rose into the sky to travel through the night with tired, heavy wings and a sad, heavier heart.

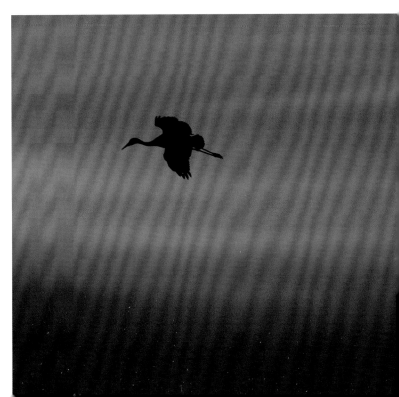

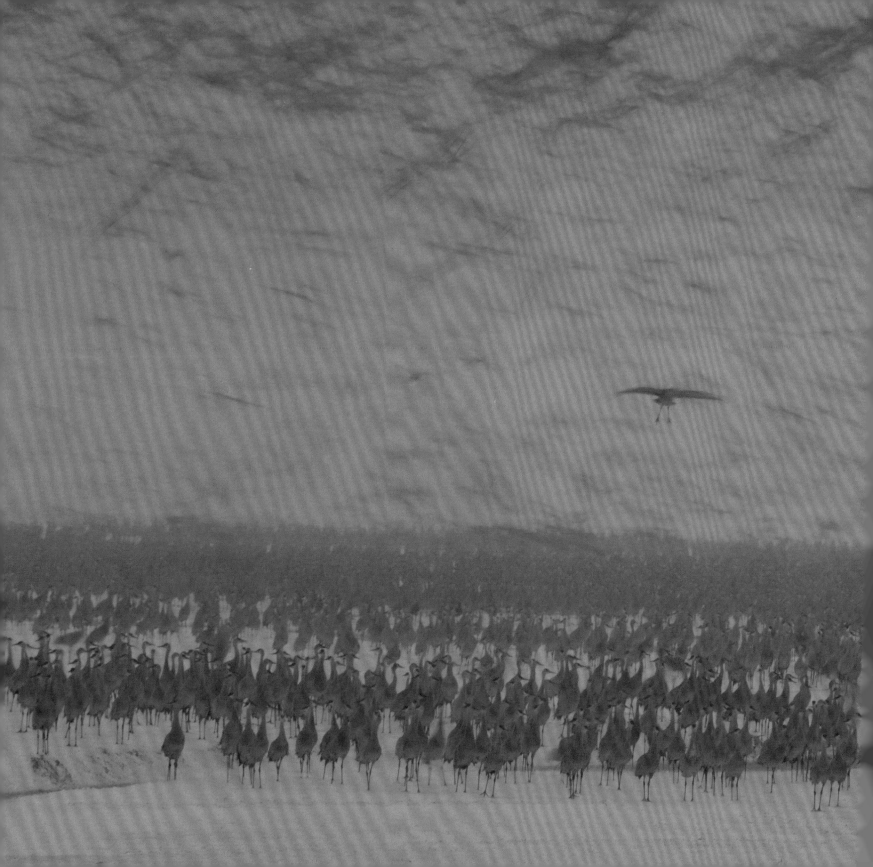

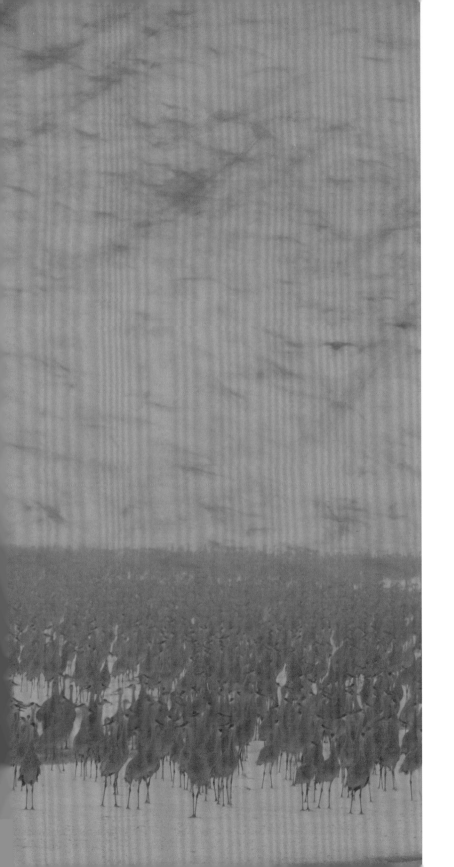

By morning, Mary's world was even colder as she landed on the snow- and ice-covered Platte River she had always loved.

As light began to fill the day, Mary looked around. Other cranes surrounded her—their unison calls making her feel even more alone.

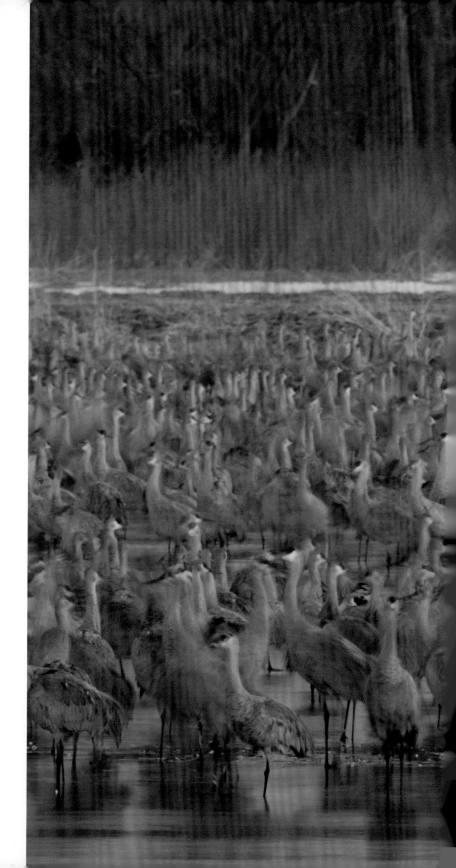

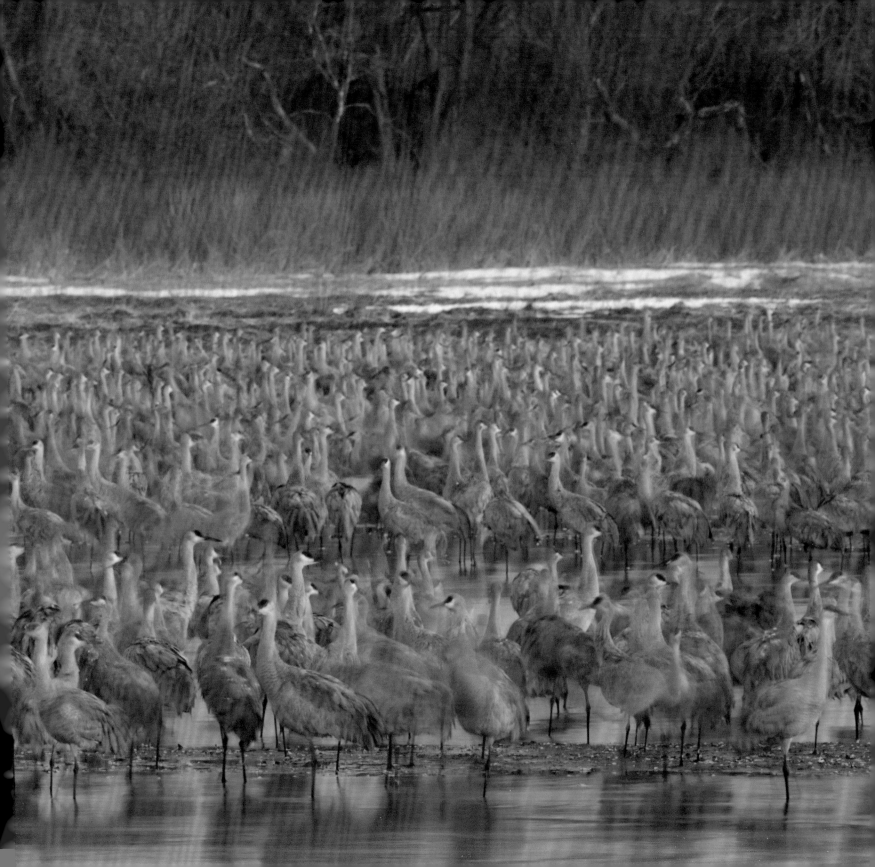

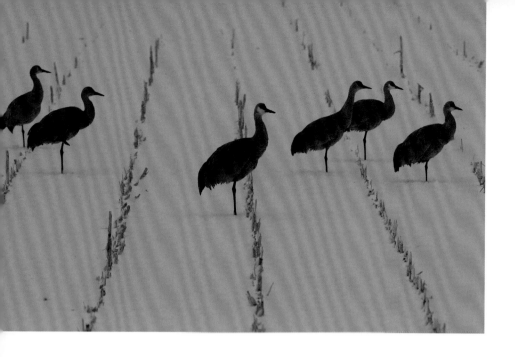

She flew to a nearby cornfield. Soon after she landed, more cranes approached.

She closed her eyes, hoping all their noises would go away. But their happiness seemed to grow ever louder.

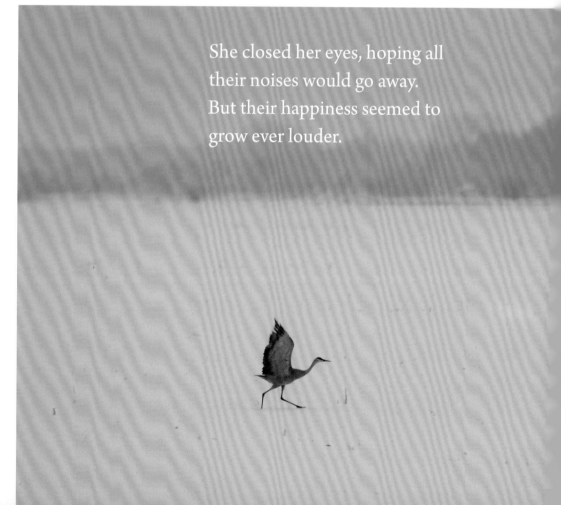

"Quiet!" she scolded bitterly, surprising herself with her outburst as she moved across the barren field away from the voices behind her, heading toward a spot near a frozen creek bed.

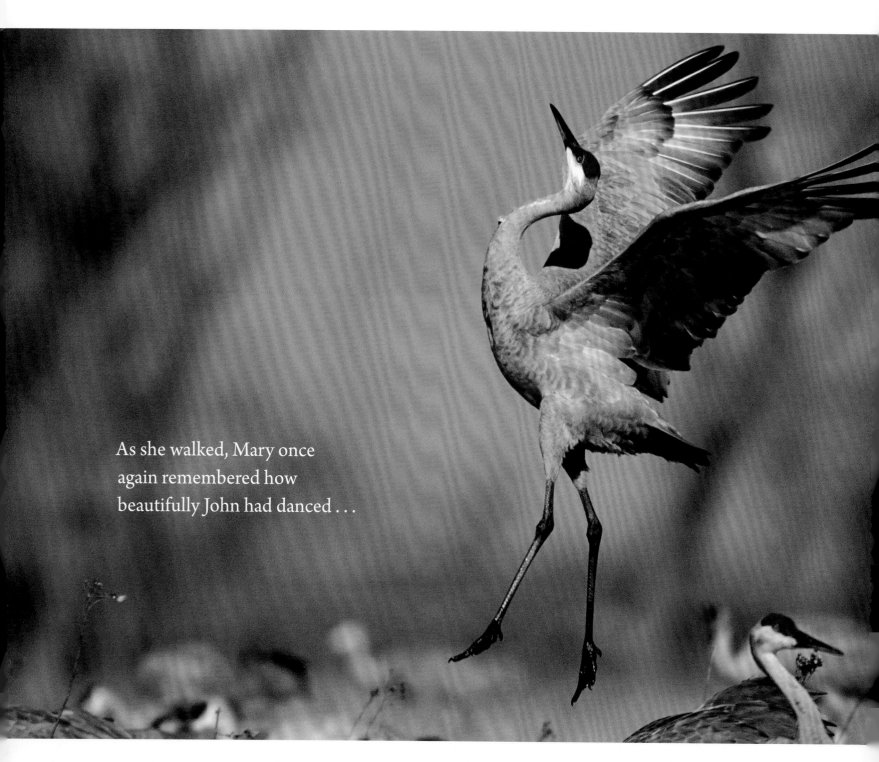

As she walked, Mary once
again remembered how
beautifully John had danced . . .

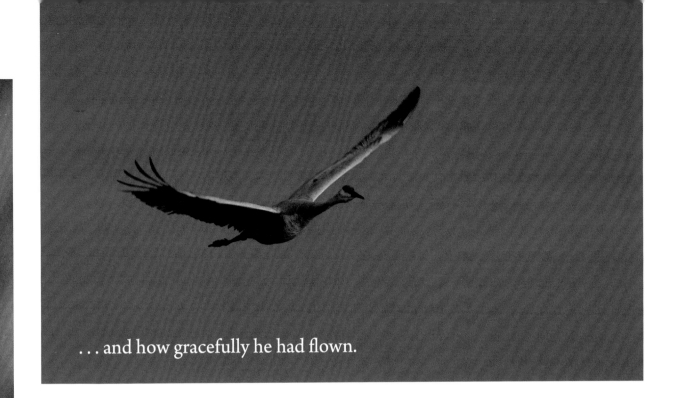

. . . and how gracefully he had flown.

She did her best to drink and eat throughout the day, while the clouds finally opened in the late afternoon and melted the newly fallen snow. A bright, full moon again rose near dark.

She needed sleep, and even though she could barely tolerate hearing all those smiling crane voices again, the Platte River's sandbars were the only place she felt safe. Reluctantly, she flew back to the river.

That night, however, despite all the
cranes being so close to her, watching
the nearby banks for predators,
Mary had never felt more isolated.

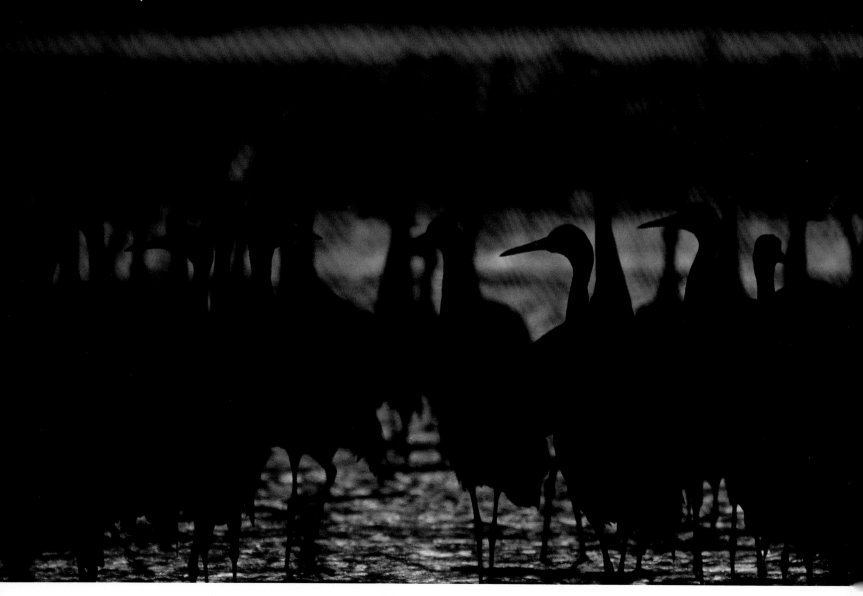

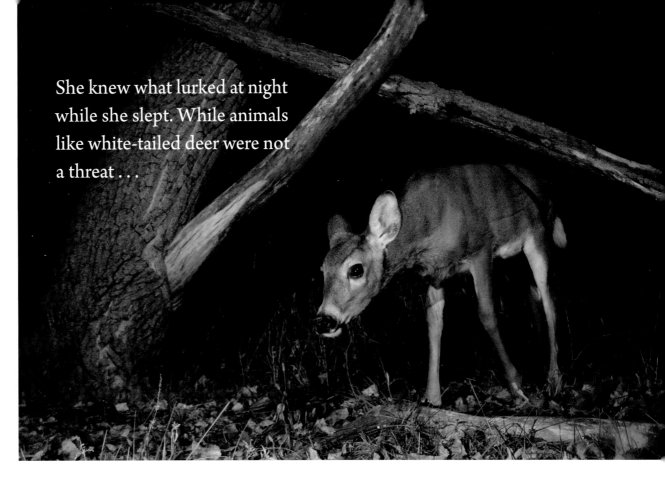

She knew what lurked at night while she slept. While animals like white-tailed deer were not a threat . . .

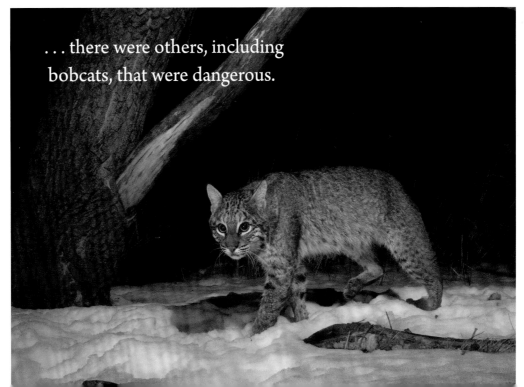

. . . there were others, including bobcats, that were dangerous.

By sunrise the next morning Mary was exhausted.
Everywhere she looked she was reminded of John.

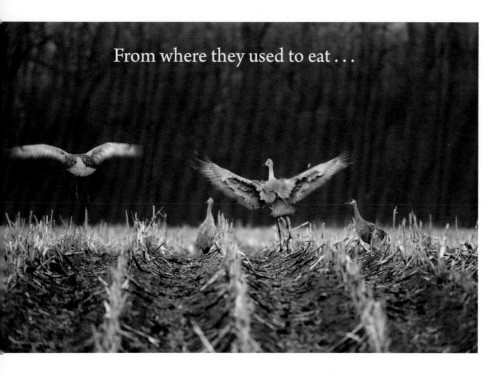

From where they used to eat . . .

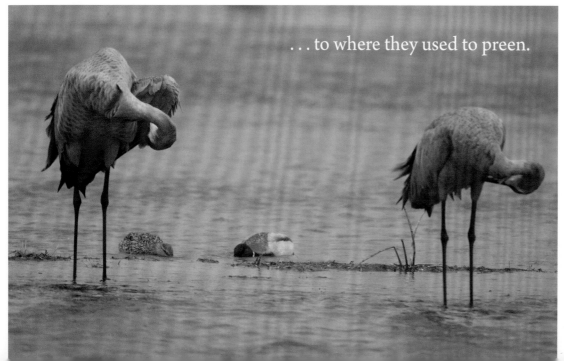

. . . to where they used to preen.

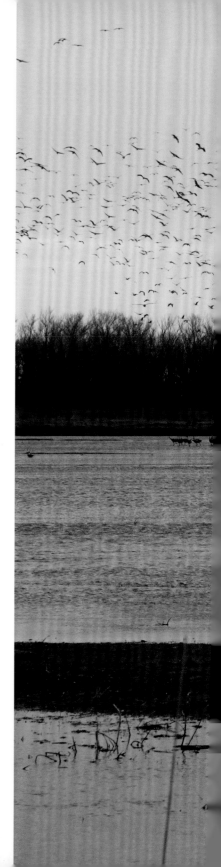

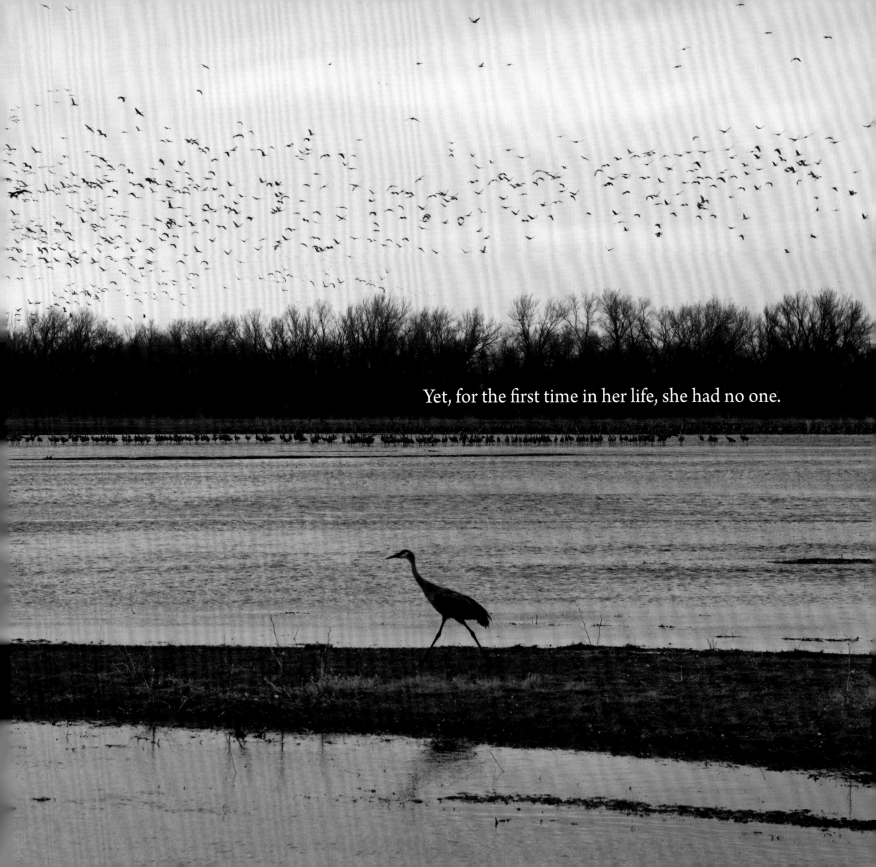

Yet, for the first time in her life, she had no one.

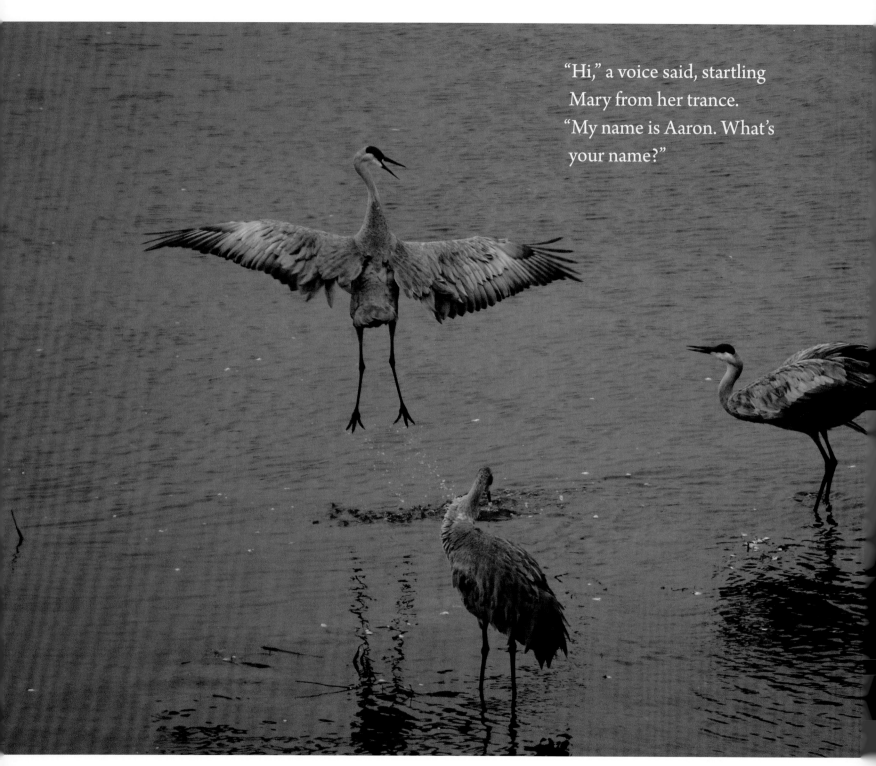

"Hi," a voice said, startling
Mary from her trance.
"My name is Aaron. What's
your name?"

Mary was silent at first. Then, "How high can you jump?" she asked.

"Excuse me?"

"How high can you jump?" she repeated.

He leapt as high as he could.

"John could jump higher," she lied. "Let's hear your contact call."

The sound from his mouth was breathtaking.

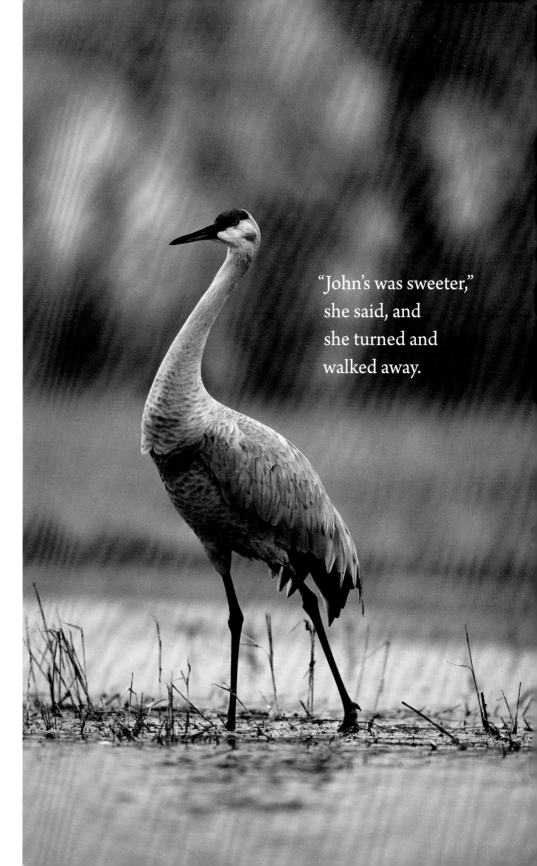

"John's was sweeter," she said, and she turned and walked away.

When she saw another crane standing by himself, she approached him.

"Can you call like John?"

"I-I can try," he nervously stuttered.

But when he did, she immediately shook her head. "No. No. No, that's not right. Can you leap into the air like John?"

"I can try."

She again shook her head. "That's not high enough."

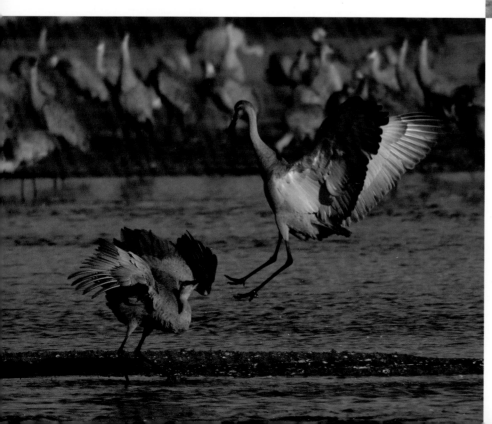

Throughout the day she continued her interviews.

"Are your feathers as beautiful as John's?" she would ask.

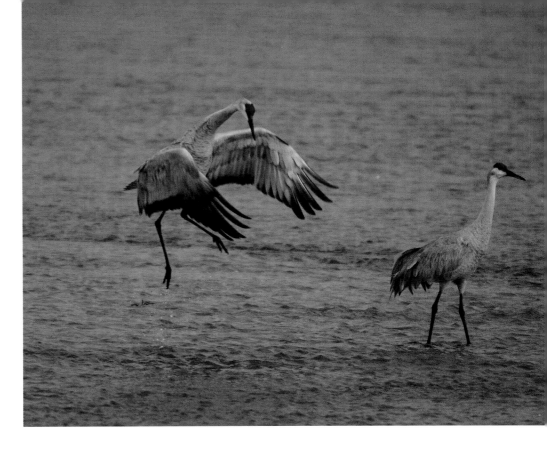

"Can you protect
yourself like John?"

"Can you dance like John?"

After a while, she wouldn't even
wait until they were finished.

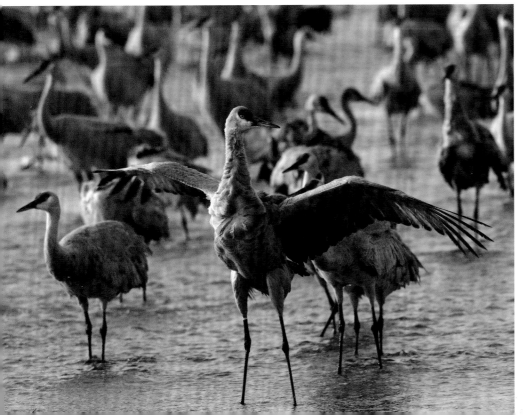

23

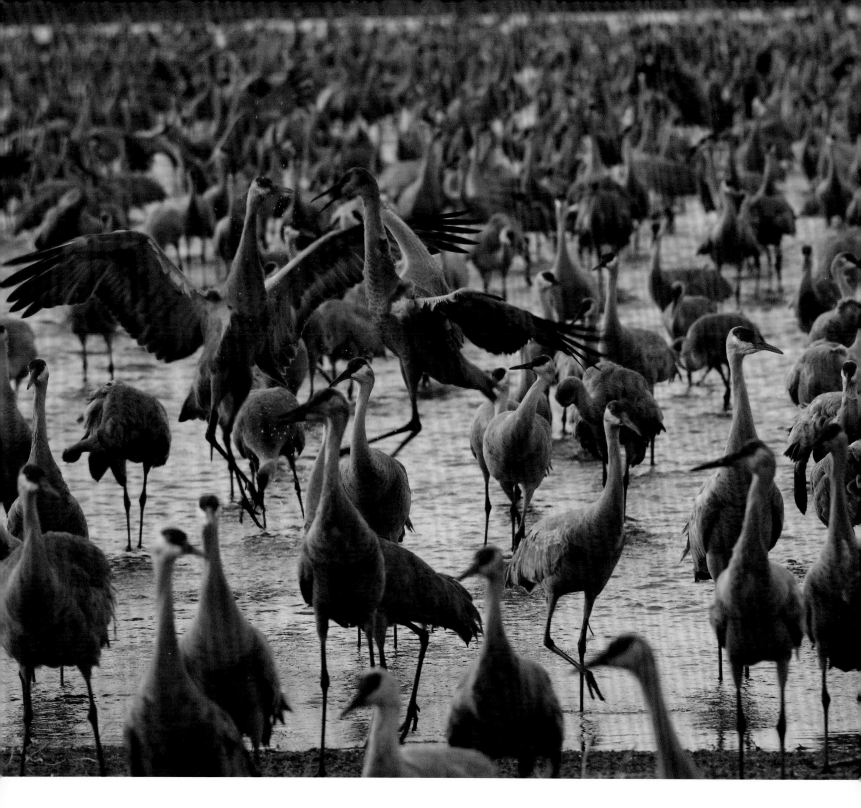

Finally, after days of questioning hundreds of cranes, she walked by another one.

"Are your wings as wide as John's?" she asked, not even bothering to stop.

"No," the crane replied.

Mary turned back to him. "Huh?"

"I can't be John," he gently said. "I can only be who I am. And my name is Ben."

"Well," she scoffed, "that just won't work." Then she began to walk away.

"What's so great about you?" he called out.

She quickly spun around. "Excuse me?"

"I've watched you walk up and down this river for days, asking everyone to perform for you. So my question is: What's so great about you?"

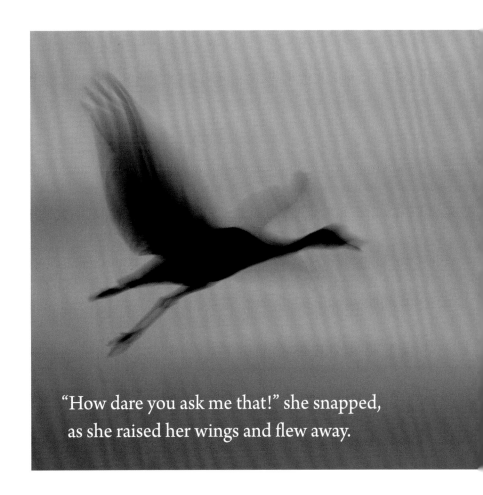

"How dare you ask me that!" she snapped, as she raised her wings and flew away.

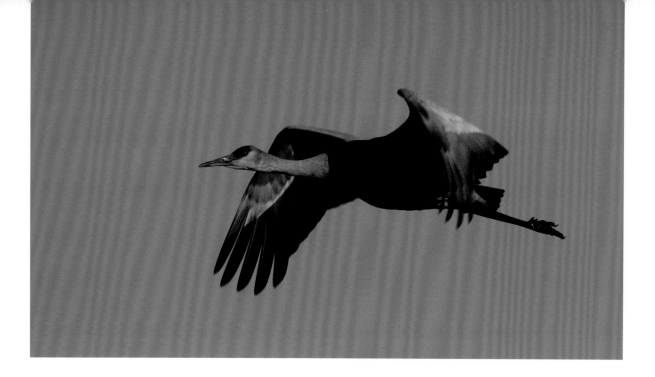

Mary had never been so angry. "What's so great about me?" she huffed to herself. "Lots of things. I'm a strong flyer . . .

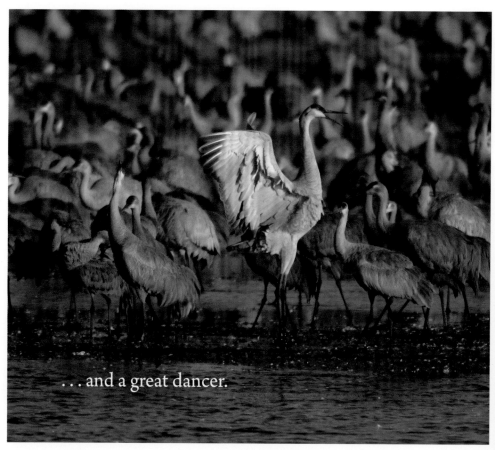

. . . and a great dancer.

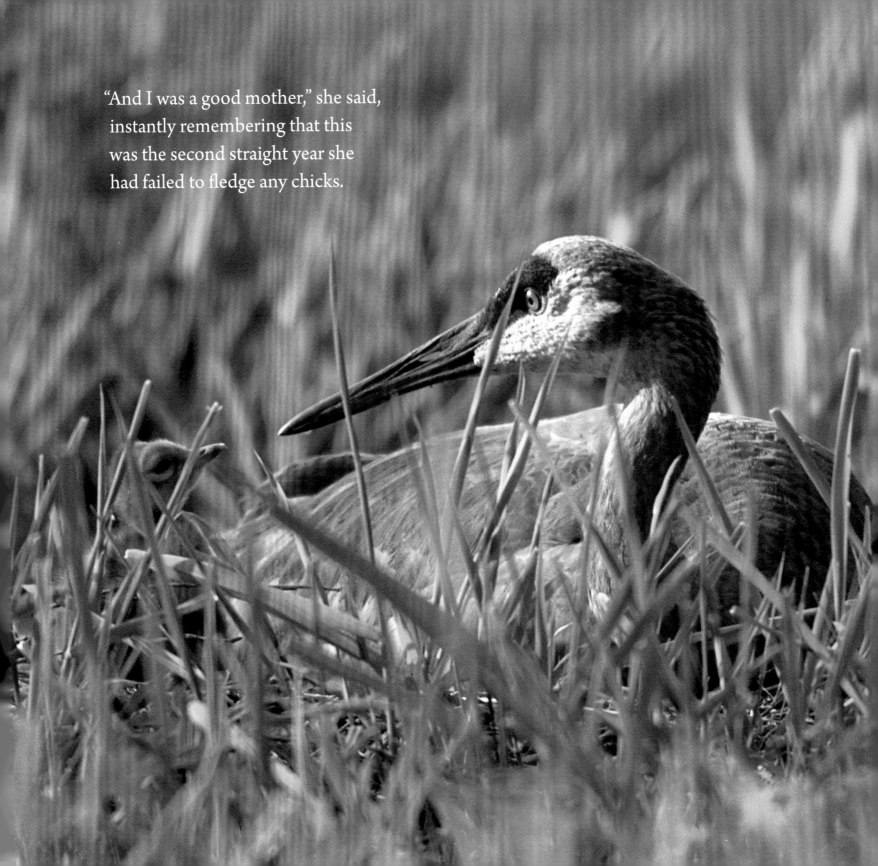

"And I was a good mother," she said, instantly remembering that this was the second straight year she had failed to fledge any chicks.

So consumed with her own anger and sadness for the next three weeks, Mary didn't notice the miracles happening around her.

She didn't see the relationships beginning in every direction . . .

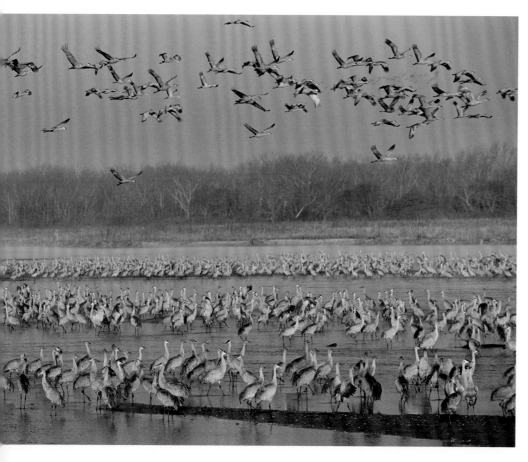

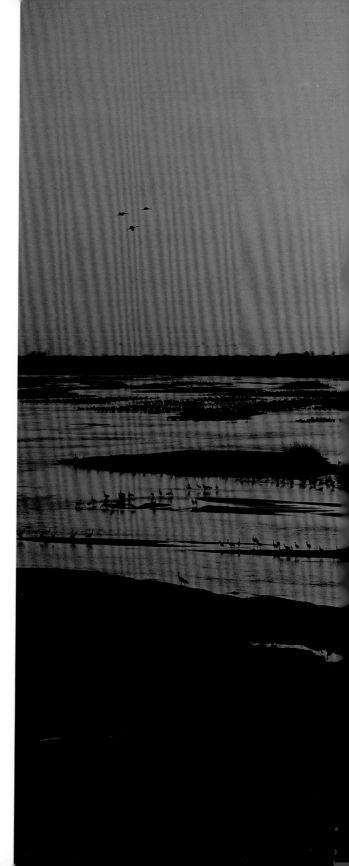

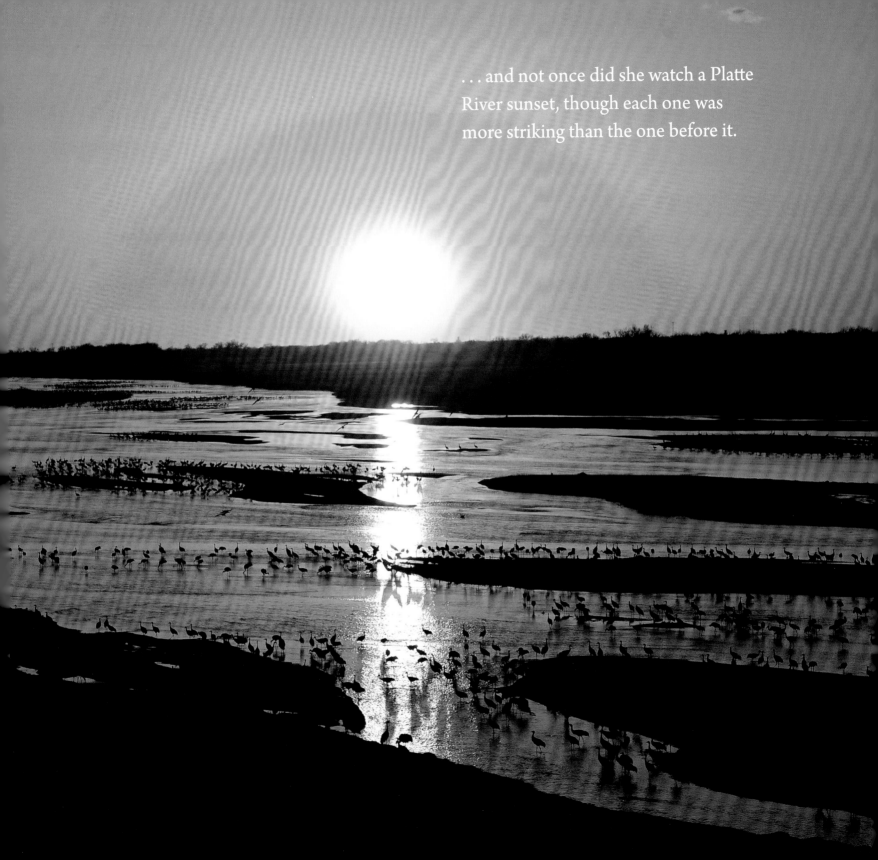

. . . and not once did she watch a Platte River sunset, though each one was more striking than the one before it.

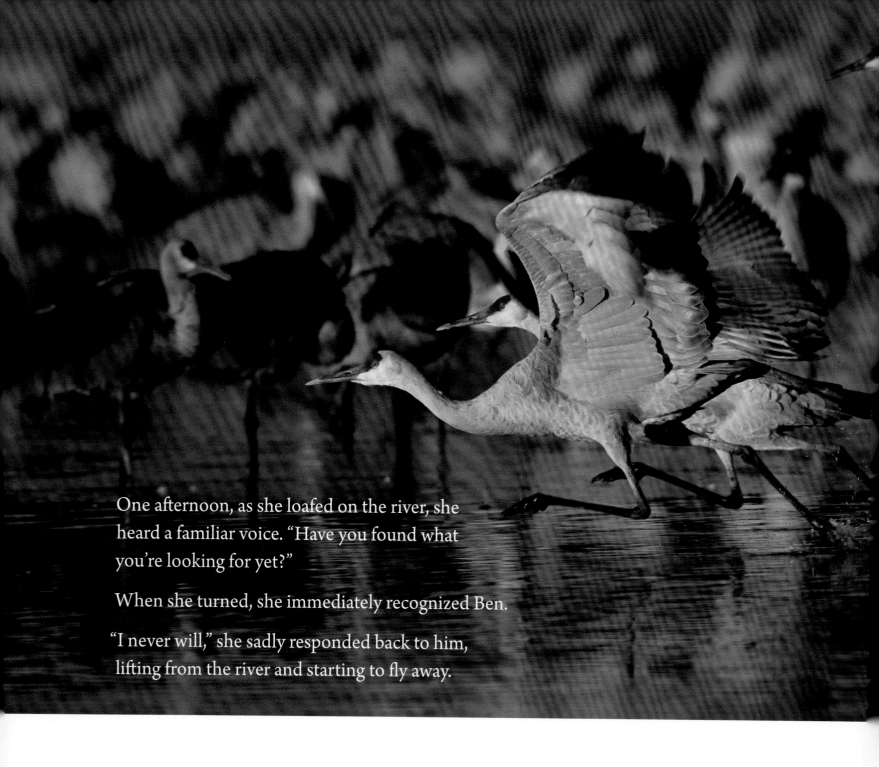

One afternoon, as she loafed on the river, she heard a familiar voice. "Have you found what you're looking for yet?"

When she turned, she immediately recognized Ben.

"I never will," she sadly responded back to him, lifting from the river and starting to fly away.

He attempted to catch her. "Neither will I!" he called out.

She stopped her wings and landed back onto the water. "What?"

"It's a long migration," he started. "Power lines, hunters, windmills— you name it. You're not the only one hurting here. You could never replace my Evelyn no more than I'll ever replace your John."

He paused, memories of what might have been going through his own mind. "But I would like us to be friends. It sure gets lonely here."

For the first time since she arrived in Nebraska, Mary was no longer thinking about herself.

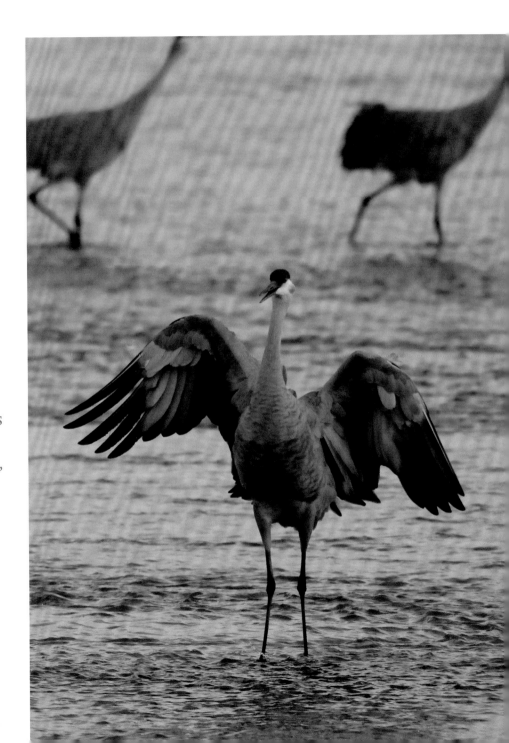

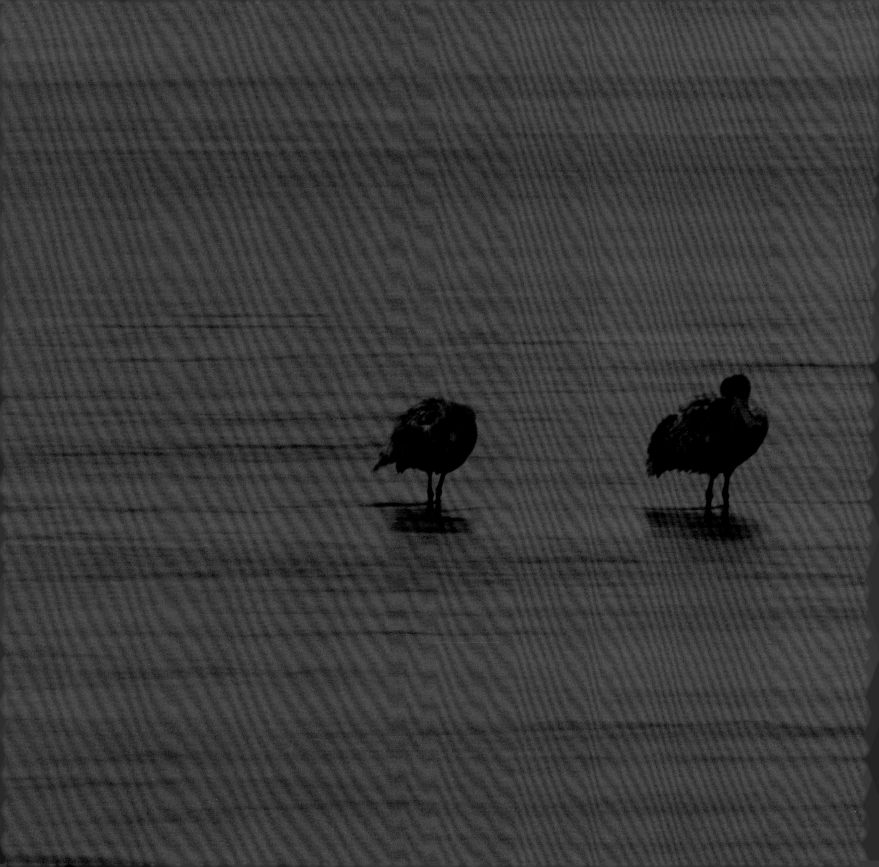

Slowly, Mary and Ben shared their stories—learning, and trusting, a little more every single day.

At night they would sleep on the same sandbars . . .

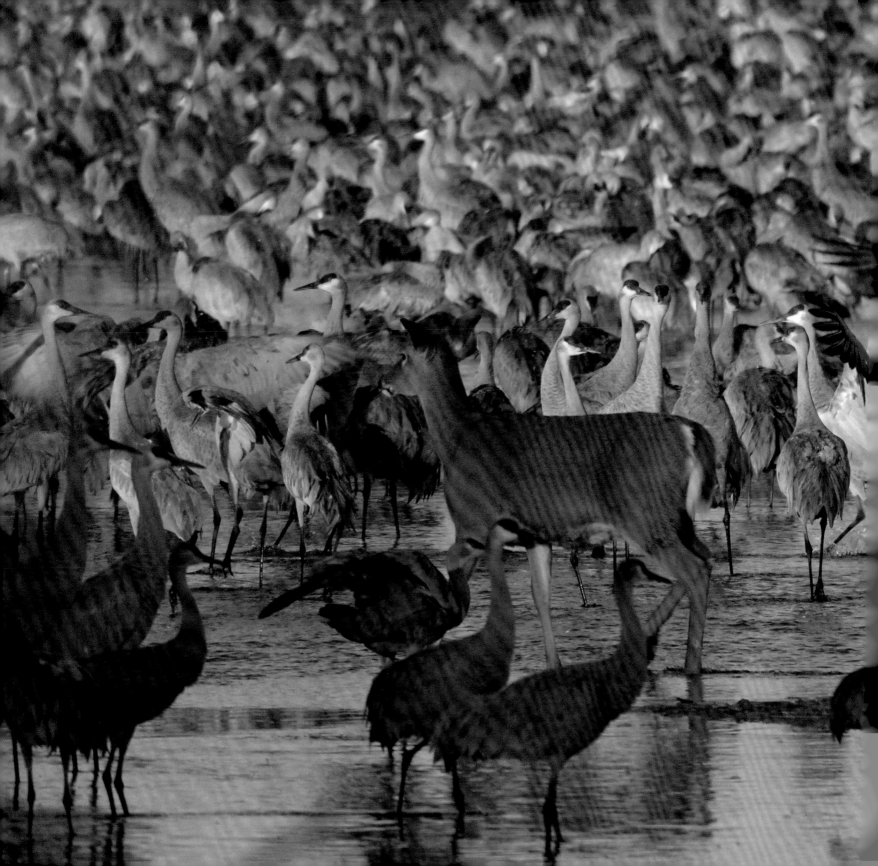

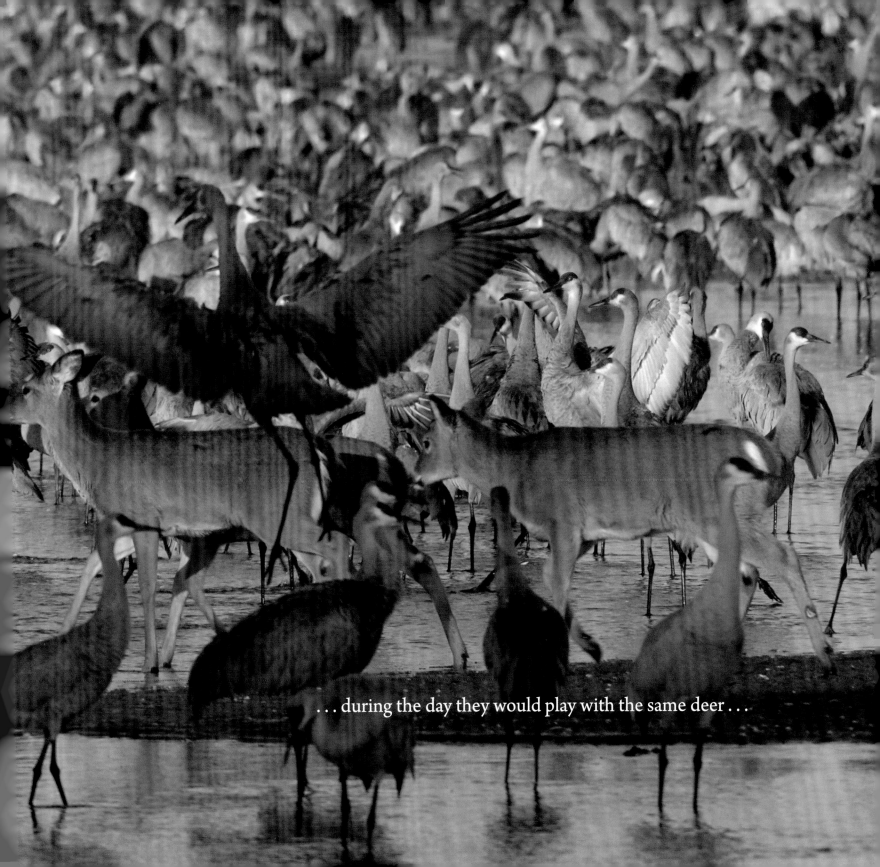

. . . during the day they would play with the same deer . . .

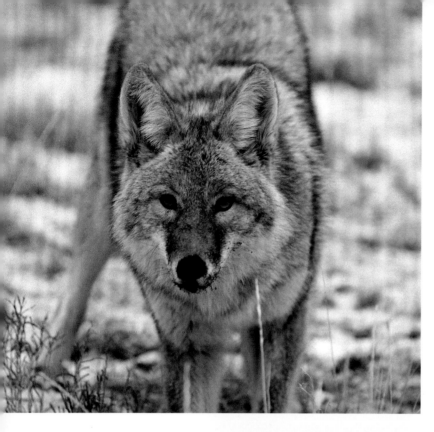

... and they always
watched for predators
from both land ...

... and sky.

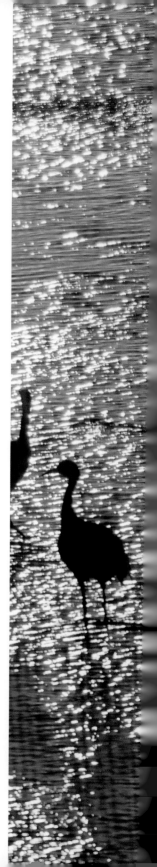

36

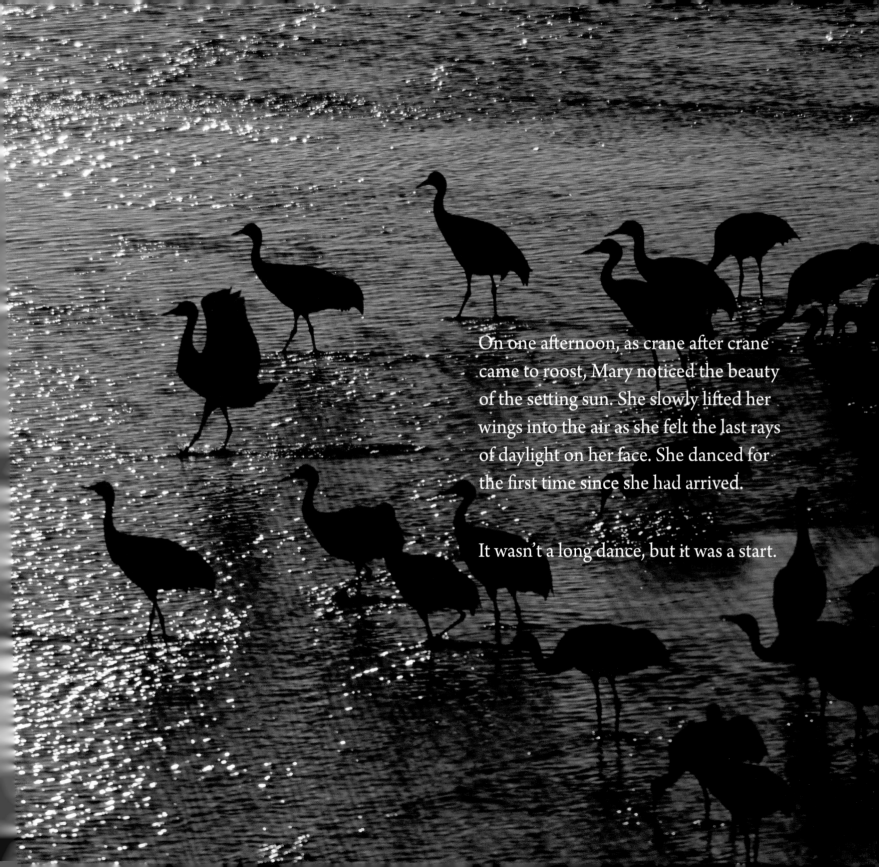

On one afternoon, as crane after crane
came to roost, Mary noticed the beauty
of the setting sun. She slowly lifted her
wings into the air as she felt the last rays
of daylight on her face. She danced for
the first time since she had arrived.

It wasn't a long dance, but it was a start.

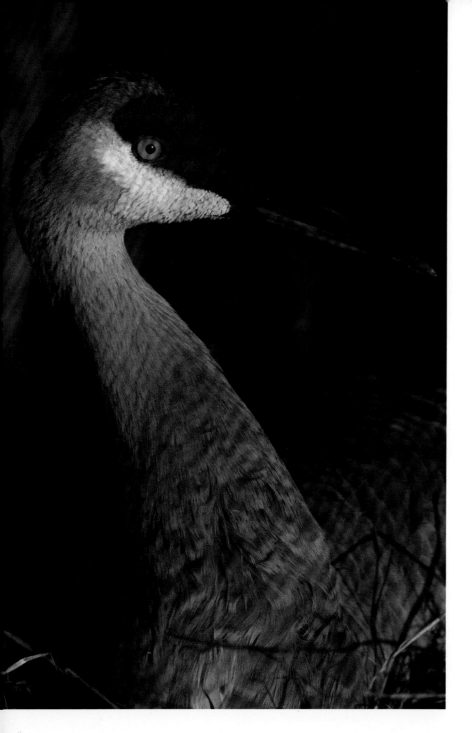

As the days continued to pass toward spring, Mary began to regret how she had treated so many cranes since she had landed.

"We've all made mistakes," Ben told her. "The best thing we can do is try not to make them again. You're a good crane, Mary, and you deserve to be happy. We all do."

For the first time in a long time, she was.

"I've also heard there is a wonderfully tasty cornfield not far from here," Ben said. "Would you like to check it out?"

"I'd like that," she replied.

As they both joined the sky in the early morning light, Mary had no idea what her future held. The only thing she knew for certain was that it was a beautiful spring morning, a day John would have loved, and experiencing it with her new friend while still holding her soulmate so close to her heart was good enough for her.

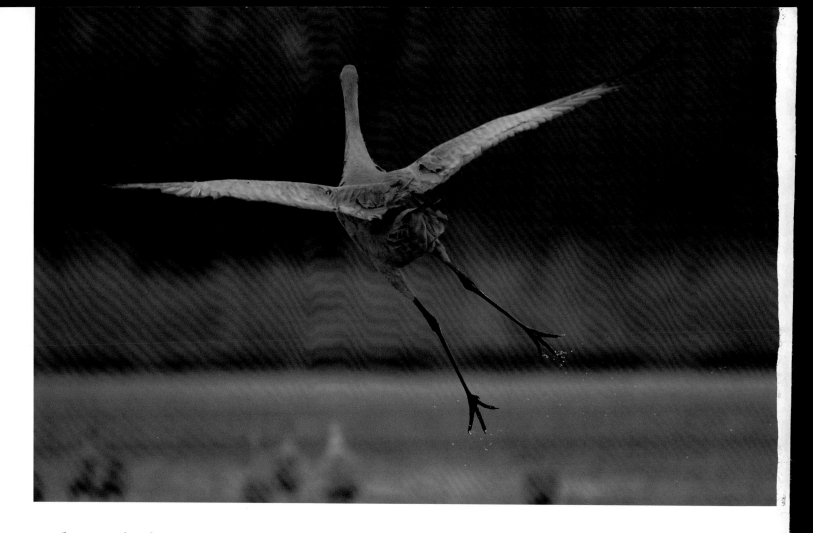

Acknowledgments

Even with a small book such as this, there was a long list of people who helped make this project happen. First off, I'd like to thank Michael Forsberg and his wife and business partner, Patty, for their work on this project. Nothing moves forward without them. I'd also like to thank the students and teachers of the Conestoga, Gretna, and Papillion–La Vista public school systems for peer reviewing this project with me. Their assistance was invaluable.

Thanks to the team at the University of Nebraska Press for their wide and varied contributions.

I'd also like to thank a host of other readers, including Amy, Feeks, Dawn, Eli, Laura, and, most notably, Mads, who is the best eight-year-old editor a dad could ever have. Finally I'd like to say thanks to Bill for encouraging me to keep Mary flying. Without your words of, how do I say it, encouragement, I never would have finished this project.